How to draw
MANGA
ROBOTS

Peter Gray

W
FRANKLIN WATTS
LONDON•SYDNEY

This edition printed in 2006

First published in 2005 by
Franklin Watts
338 Euston Road
London NW1 3BH

Franklin Watts Australia
Hachette Children's Books
Level 17/207 Kent Street
Sydney NSW 2000

Produced by Arcturus Publishing Limited
26/27 Bickels Yard, 151–153 Bermondsey Street
London SE1 3HA

Editor: Alex Woolf
Designer: Jane Hawkins
Artwork: Peter Gray
Digital colouring: David Stevenson

A CIP catalogue record for this book is available
from the British Library

ISBN 07496 6636 6

Printed in China

Contents

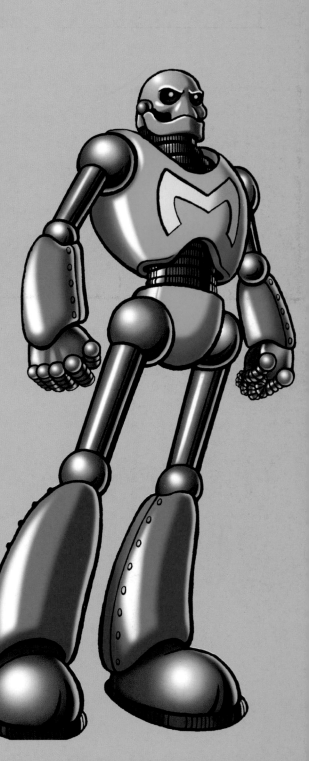

Introduction

Manga comics are full of robots, also known as mechas. These towering hulks of high-powered metal can fly, swim, fire weapons and fight epic battles with their enemies.

Most manga robots are humanoid, or based on the human shape. But unlike human characters, you can fit out your robot characters with all sorts of fun gadgets or weapons. You can even give them wings!

The other great news is that drawing manga robots is a lot easier than drawing humans. If you can draw blocks and circles, then you're already halfway there.

How to Draw Manga Robots has plenty of projects to get you started and to inspire your imagination. Don't be put off by the slick look of the artwork produced by professional artists. It isn't that hard to achieve once you know some of the tricks of the trade.

The most important skill for any aspiring manga artist to develop is the ability to draw, and this will only come about if you keep practising. All this effort will pay off eventually, and you will notice how much more inventive and interesting your drawings become.

Magnus

This is Magnus, a robot with a heart of gold — literally! He might be a lump of metal but he has an intelligently programmed brain that can make you believe he really has a sensitive soul. Magnus will be modelling for us later in the book. He will also pop up from time to time with drawing tips and suggestions.

Materials

For the exercises in this book, it will help you to use a hard pencil for sketching light guidelines and a soft pencil for making the final lines of each of your drawings distinct. Pencils are graded H, HB or B. H pencils are the hardest. These pencils will make lighter lines. B pencils are softer and will make darker lines. Most general-purpose pencils are graded HB. Get an HB mechanical pencil if at all possible, since this will produce a constant fine line for your final image. If your pencils aren't mechanical, they'll need sharpening regularly.

You'll need an eraser too, since you'll have to sketch a lot of rough lines to get your drawing right and you'll want to get rid of those lines once you have a drawing you're happy with. Keep your eraser as clean as possible.

When it comes to colouring, coloured pencils are easiest to use. You might want to start with them and then move on to felt-tip pens and watercolour paints when you have developed your skills further. Cheap photocopier paper is quite adequate for most types of drawing. Only if you're working with paints should you purchase thicker paper since it won't tear or buckle when it gets wet.

Basic Techniques

Before we get started on drawing robots, we're going to take a look at some of the basic rules of picture design and colour theory.

Composition

Composition is one of the first things to consider when making a picture. It's all about where you place the elements you want to include in your picture. Here we're going to look at the most basic rules of composition.

Portrait format
A picture that is taller than it is wide is known as portrait format. The two pictures on this page show Magnus in a portrait-shaped frame.

1 Bad placement
When people are taking photographs, you'd be surprised how often they make the mistake of automatically placing the focal point of the picture – in this case, Magnus's head – smack in the middle of the frame. The same thing can happen when someone draws a picture. Here Magnus is placed too low. His head sits halfway down the frame, as marked by the green line. There is too much empty space above his head and he looks like he's going to drop out of the bottom of the picture.

2 Vertical placement
The height of an object within the frame is known as the vertical placement. This picture shows good vertical placement. Magnus fills the frame nicely, without too much empty space and without having any of his body parts cropped off.

Landscape format

The pictures in these frames are wider than they are tall. Called landscape format, it is normally used by photographers and artists when they want to capture a wide expanse of scenery.

1 Horizontal placement

The position of an object along the width of the frame is known as the horizontal placement. Here Magnus has been placed centrally. Although this can sometimes work well, more often than not it looks boring and should be avoided.

2 Golden section

It is generally accepted that pictures work better when the objects are placed to the left or right of centre. The ancient Greeks worked out a geometrical equation known as the golden section, and today's artists still use it. In simple terms it states that objects should be placed just over a third of the way in from the picture's edge.

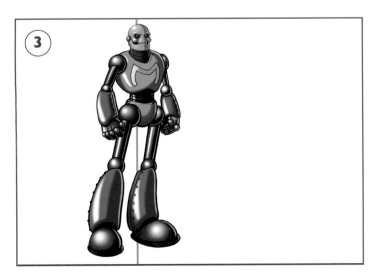

3 Moving left or right

Placing Magnus to the left or right and placing him roughly on the lines of the golden section immediately makes for a more interesting picture.

Colour Theory

The colours you use for a picture will have a major impact on its final look and feel. Here Magnus is proudly modelling some simple colour schemes.

1 Primary colours

Red, blue and yellow are the basic colours from which all other colours can be mixed. They are called primary colours. If you can only afford three coloured pencils, pens or paints, go for these colours.

2 Secondary colours

Green, purple and orange are called secondary colours. Each one is a combination of two primary colours. In these three pictures, the two colours of Magnus's limbs are mixed together to make the colour of his chest armour.

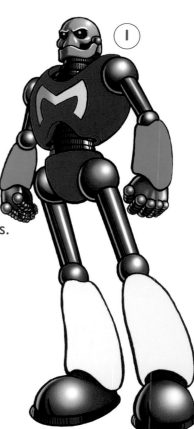

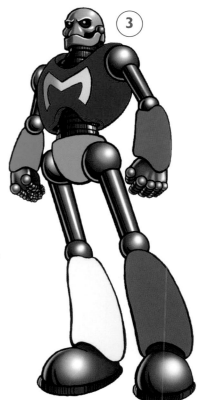

3 Full spectrum

The three primary and three secondary colours make up the full spectrum of pure bright colour. Putting all of these colours together in one picture can be overpowering, so it's usually wise to limit the number of colours you use.

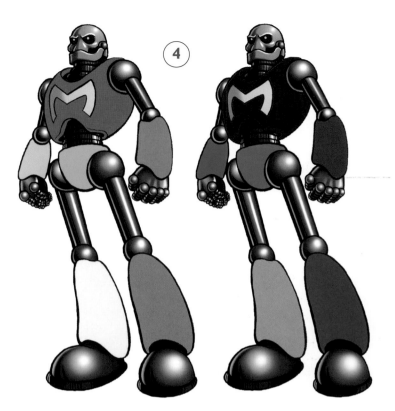

4 Tints and shades

When colours have white added to them, they are called tints and will look pale. When colours have black added to them, they are called shades and look darker. Here the same colour has been used for each of Magnus's body parts, but for the picture on the left, white was added to produce a pastel version. For the second picture, black was added to produce a darker version.

5 Complementary colours

Some colours go together better than others. Every primary colour has a secondary colour as its complementary colour, which is a combination of the other two primaries. For example, red is complemented by green (blue plus yellow). Here Magnus is dressed in various tints and shades of blue and orange (yellow plus red).

6 Harmonious colour schemes

To help convince you that you don't always need to use lots of different colours, this picture has been coloured using only tints and shades of green. There is certainly no chance of any colours clashing here!

Light and Shade

To use colour effectively, you need to understand how light and shade affect an object.

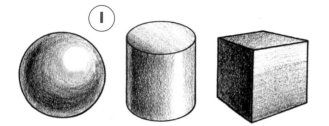

1 Daytime shadows

Light is hitting these shapes from an upper-right direction. The surfaces facing towards the light appear brighter than the parts that face away. The parts facing away will not be completely black, however, because light also bounces off other objects to faintly illuminate these areas.

2 Night-time shadows

At night, when objects are lit directly from artificial light sources, there may be no light reflecting off other things. The parts of an object that face away from the light source can merge into the darkness.

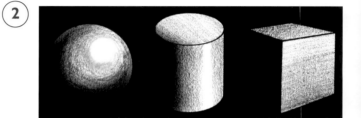

3 Simple shading

First decide on the direction the light is coming from, then lightly shade the surfaces of your picture that aren't facing the light directly. In this picture, the light is coming from top right again. Use a very soft pencil, holding it at an angle but without pressing down too heavily.

4 Creating shadows

Some parts of a complicated object like this robot will block out the light from other parts. An arm might cast a shadow on a leg, for instance. Keeping the light direction in mind, imagine where various body parts might cast shadows on other parts and shade those areas darker.

5 Hidden areas

Some parts of the robot are tucked away, like the little crevices under close-fitting joints. Shade these parts more heavily.

6 Angles

Polish your picture by working across each body part and imagining the subtle ways that light falls on it. Shade the parts to different degrees, depending on the angle of each part in relation to the direction of light.

7 Adding backgrounds

Here is the finished picture against two different backgrounds. A grey background makes the lighter areas stand out more and helps show the effects of reflected light around the left and lower edges of the body parts. If you put the same drawing on a black background and remove the reflected light, it blends in with the background completely.

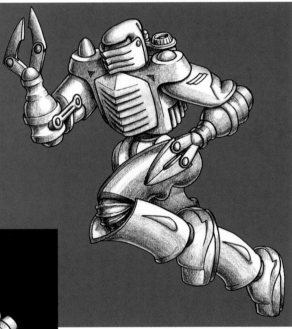

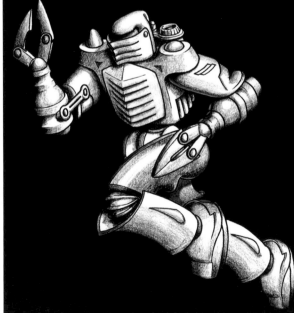

Colouring

Here I'm using artist's quality marker pens to colour Magnus, but you can get similar effects with ordinary felt-tip pens.

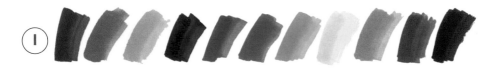

1 Robot colour swatches
Magnus is really only five colours: grey, blue, green, yellow and gold. To show how light falls on him (from top left), we also need to use darker shades of each of these colours, so you'll need felt-tips in the different shades you can see here.

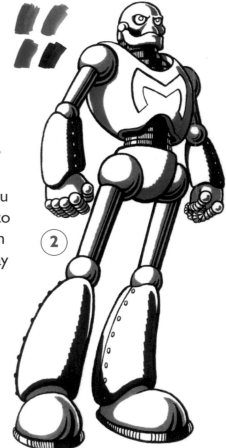

2 Adding the colour
First use your darker shades. The colours you need are shown next to the picture. Apply them to the areas facing away from the light and to areas that are in the shadow of other parts of the body.

3 Larger areas
Now you can colour the bigger areas using lighter colours. When you do this, leave some strips of white. This will have the effect of making the surfaces look shiny.

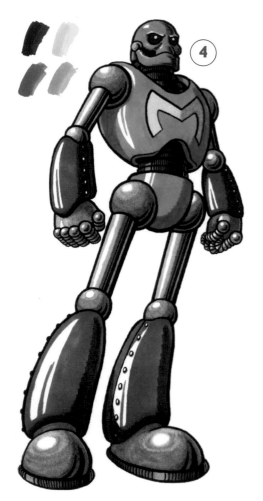

4 Smaller parts

Continue to add colour using the swatches next to the picture to guide you. Notice how I've used different greys to enhance the shine patterns on the metalwork.

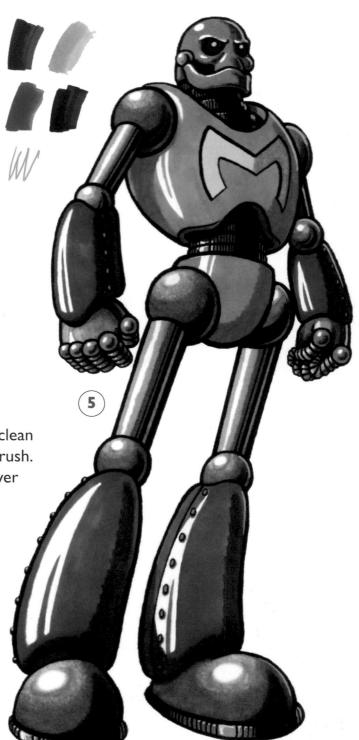

5 Final colour

Once you've finished with your felt-tips, you can clean up your picture with some white ink and a fine brush. Use these to blot out any colour that has bled over the lines and to add highlights to the metalwork. Finally, add a glow of reflected light to the right-hand side of the picture. Draw thin strips of white on the head, chest and arm, let this ink dry, then use a fine-nibbed felt-tip pen to colour these strips light blue.

erspectiv

In this section we will look at perspective — the angle and height from which you view an object. Then we will try out some projects that use the techniques we've learned.

Anything you draw will be affected by the angle and height of your viewpoint. With the skeleton framework of a human at a 3/4 angle, we can see that it looks different depending on our eye level.

1 Mid perspective

The horizontal blue line represents our eye level. The red lines help us to see that all the parts of the body that are above our eye level appear to slope down as they recede and those below our eye line slope up. All of these angles converge at a single point on the horizon.

2 High perspective

Here the horizontal blue line shows that the same skeleton is now below our eye level so all parts of the body appear to slope upward as they get further away from us.

3 Low perspective

If we look at the figure so it's above our eye level, all parts of the body appear to slope down to the left.

Creating Magnus

This is a 3/4 view of Magnus the robot with lines added to help you get the perspective right.

Step 1
Draw three oval shapes for the body parts as shown. Add a curved vertical guideline to each body part, then draw a horizontal guideline across the head. Notice how the ends curve downward. Copy the angles of the three sloping perspective lines.

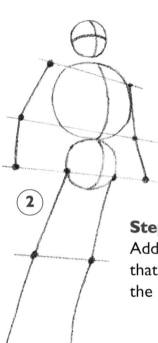

Step 2
Add the arm and leg bones. Notice that the perspective lines run through the joints.

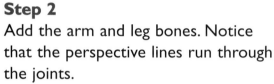

Step 3
Make the shape of the upper arms and legs by drawing different-sized circles connected by parallel lines. Outline the large boots too.

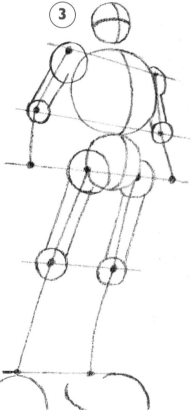

Step 4
Now outline the metalwork of the forearms, hands and lower legs.

Step 5

Draw the outline of the metal suit surrounding the chest and hips. Work on the main features of the head and add a bit more detail to the lower legs and feet.

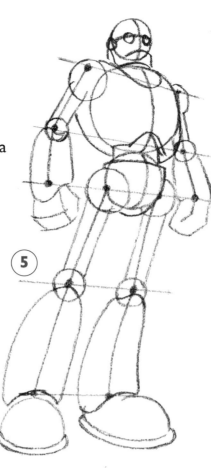

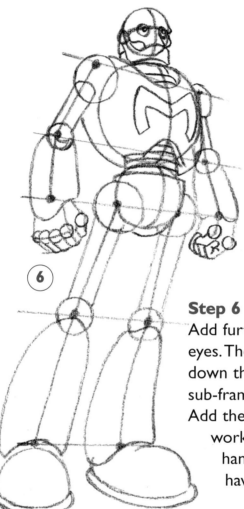

Step 6

Add further detail to his face and eyes. The rows of horizontal lines down the front of the body create a sub-frame made up of metal discs. Add the letter M to the chest and work on the detail of the giant hands. The thick metal fingers have large circular joints.

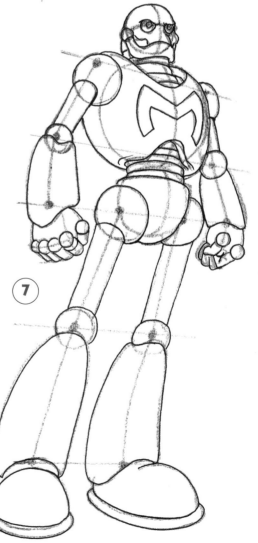

Step 7

Pick out all your good lines to form the shape of your final drawing and go over these in heavy pencil. Now go over all your final lines again using a black felt-tip pen. Finally, study the picture carefully to see if you've missed any little details.

(8)

Step 8
When the pen ink dries, erase all the pencil lines that formed your original framework to leave a clean drawing of Magnus. Notice how I've added lots of thin vertical lines to the discs that make up the torso. Now colour him in.

Two-point Perspective

Knowledge of one-point perspective is all you need for many of the figures you will draw. But if you are tackling a figure that is very solid and blocky, like the robot featured next, it will help you to understand a bit about two-point perspective.

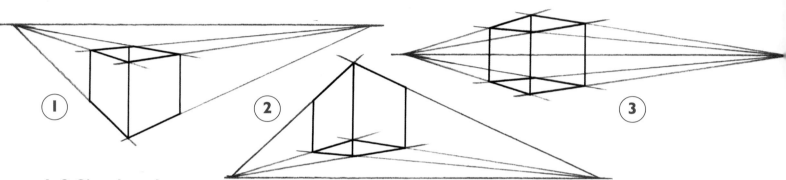

1–3 Simple cube

These diagrams show the effects of perspective on a simple solid cube. You'll notice that the angles recede in two directions. This is two-point perspective. The two points form a horizontal line known as the horizon, or eye line. For the first picture, the eye line is above the cube; for the second picture, it's below the shape; and for the third, it's in the middle.

4 Stacked cubes

If we stack these cubes on top of each other, we have a shape that could form the basis of a three-dimensional figure that is drawn in perspective.

5 Robot blocks

This diagram shows the main blocks that make up the body of the robot we will be drawing next. Because the head and chest are at a different angle from the hips and legs, the points at which the angles of the body converge are different. They still meet on the horizon. This is always the case with objects that stand level with the ground.

Giant Robot

Before you start drawing, take a look at the finished character on the next page so you know what you're aiming for.

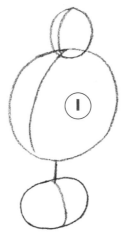

Step 1

Start with the basic masses that form the head, chest and hips. Like Magnus, the chest is much larger than the head and hips. Notice how the vertical guideline is in a different position on the hips, as the figure is twisting.

Step 2

Although this robot doesn't really have bones and joints, drawing them will help you work out the positions of the robotic limbs, and where they bend. I've added some perspective lines to help you draw the legs. The leg to the right of your picture is further away, so it appears shorter.

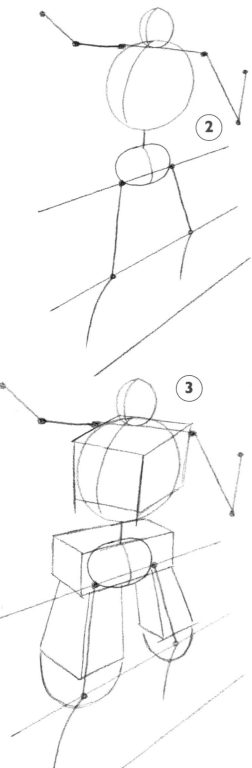

Step 3

Turn the chest into a cube and draw a rectangular box around the hips. Use a ruler if it helps. Copy the blocky shape of the upper legs, making the nearest leg thicker. Draw semicircles for knee joints.

Step 4

Add more blocks to form the rough shape of the lower legs and the robot's arms.

Step 5

Start to refine your robot's shape. Make the chest more angular, turn the waist into a narrow, curvy tube, and add a power pack to the robot's back. Copy the rest of the metalwork and make the basic shapes of the hands. To draw the giant outstretched hand, start with the framework for the finger bones, then map in the palm and the sockets for the fingers.

5

Step 6

Add the segmented parts of the fingers. Refine the shape of the hand that is on the right in the picture.

The helicopter gives the picture a sense of scale — we can now see that this robot is about the same size as a skyscraper.

6

Step 7

Go over all your good lines in heavy pencil, then in black felt-tip pen.

Step 8

When the ink is dry, erase all your pencil marks. Now you can enjoy adding colour. I've added some strips of white to make the metal look like it's reflecting the light. The helicopter is bright green so it stands out against the colours of the robot's body.

7

8

Projects

Having got this far, you should feel fairly confident about drawing manga robots. Now here are some challenging projects to sink your artistic teeth into. Once you've mastered how to draw these robots, you should be well equipped to release any number of your own mechanical creations into the manga world.

X-O-Dus – Head

The mecha X-O-Dus is heavily armoured and equipped for close combat fighting.

Step 1
Begin with a long vertical line, then draw a smooth arch across the top. Copy the shapes that make up its jawline and chin. Draw a horizontal and then two vertical lines going up from the corners of the chin. Join up those lines with curves that follow the lines of the jaw.

Step 2
Now add the spikes and draw another horizontal line just below the crown of the helmet. Join the ends of that line to the sides of the helmet at the point where your curved lines end. Within the rectangle in the middle of the brow, draw a hexagon and a diamond shape.

Step 3
Break up the curve of the jaw and chin area. Add extra lines inside your new jawline to make the picture look more 3-D. Some more straight lines inside the "ear spikes" and the forehead hexagon will add to the effect. Add horizontal lines to the visor. Draw two circles that will be left white for its eyes.

Step 4
X-O-Dus provides good shading and colouring practice because its helmet is made up of flat and curved surfaces, all of which reflect light differently.

22

X-O-Dus – Figure

Step 1

X-O-Dus is basically human in shape but broader and with big joints. You're only blocking in rough shapes at the moment, but try to get the proportions right.

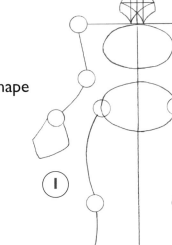

Step 2

The body shape here is more like armour than flesh. Shoulders, hips and limbs are all huge except for its upper arms, which have no armour because they are protected by the shoulder armour and need to be able to move freely.

When shading in, notice that X-O-Dus has a dull metallic surface with deep shadows and bright highlights. You might find your eraser very useful as you finish the drawing.

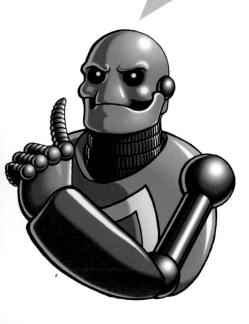

Step 3

You have to think three-dimensionally and try to show in a few simple lines the solidity of this powerful robot. Just like its helmet, X-O-Dus's body is a mixture of curves and angles. Erase your guidelines as you go so that you don't get confused.

Step 4

Adding the details to X-O-Dus will give it that hard, military look. Don't forget to draw its joints. That will imply the way it moves in battle and add to its scariness.

④

⑤

Step 5

When shading and colouring, remember to think about where the light is coming from. Leaving the paper white in places can be very effective. You can also use white paint to add highlights at the end.

X-O-Dus – In Action

Step 1

Here's a tricky picture of X-O-Dus. The head is seen from the front, but its shoulders are at an angle, and it is swinging its right arm back while its left arm comes forward. When you run, your arms and legs work opposite to each other, so draw the right leg coming forward and the left leg bent under it.

Step 2

This is similar to the last drawing of X-O-Dus on pages 23–4, except that you see less of its torso. As you add the hand shapes, you'll notice that its left hand overlaps its leg, but you can erase the guidelines underneath.

Step 3

Now you are ready to sharpen up the shapes and sort out the details. Hands and feet are important, as always, and work on the angular quality of the legs.

Step 4

Those all-important mechanical details will finish off the picture. This is a sophisticated drawing, so pat yourself on the back when you've got it to this stage. When you're happy with it, you're ready to have fun with the colouring.

Designing a Robot

All sorts of everyday objects can provide inspiration for drawing robots. Here are some of the objects I found lying around my home. They are all quite ordinary things, but any of their features or geometric qualities could be incorporated into the design of a new robot character.

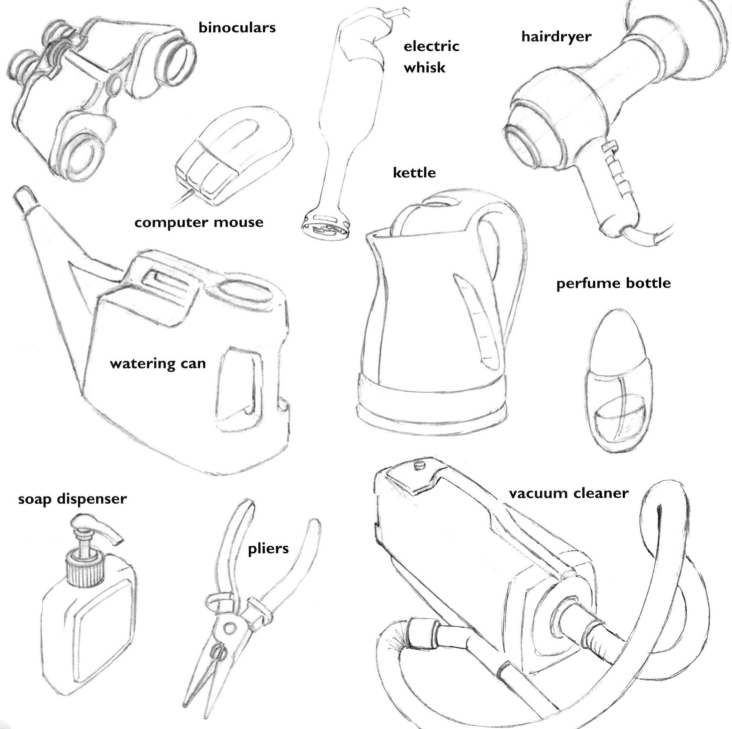

box cutter

binoculars

electric whisk

hairdryer

computer mouse

kettle

watering can

perfume bottle

soap dispenser

pliers

vacuum cleaner

Junk Robot

Here are some of the household objects assembled into a very rough robotic form. Notice, for instance, the giant binoculars that form the power pack on the back. This design still needs a lot of work – the last thing a manga super mecha wants is to look as if he's made from giant kettles and vacuum cleaner parts. Before you turn this page and find out how I develop him further, try the following exercise.

Exercise

Find some objects that interest you around your home, or pictures of objects in books. They might be airplane parts, engines, tools, electronic items or anything else that could be made to look robotic. Build up a few pages of small sketches of these items, then try using all or part of each object to assemble a robot of your own.

Developing the Robot

To bring our collection of junk to life requires a few more stages of development.

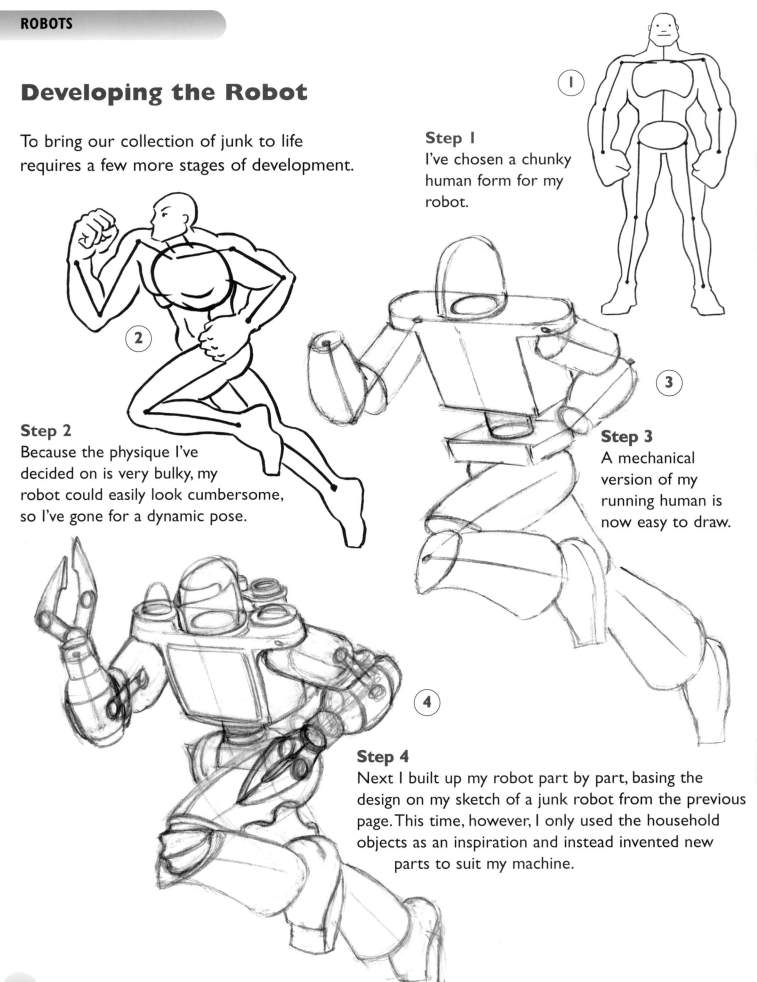

Step 1
I've chosen a chunky human form for my robot.

Step 2
Because the physique I've decided on is very bulky, my robot could easily look cumbersome, so I've gone for a dynamic pose.

Step 3
A mechanical version of my running human is now easy to draw.

Step 4
Next I built up my robot part by part, basing the design on my sketch of a junk robot from the previous page. This time, however, I only used the household objects as an inspiration and instead invented new parts to suit my machine.

Step 5

To further disguise my source material and to give more of a manga feel, I've added some extra details like the slatted metal visor and chest panel. When you're happy with your robot, go over it in black pen. Once the ink is dry, erase all remaining pencil marks.

Step 6

Before colouring your own robot, you might like to flick back to pages 10–11 to see how you might approach shading and so give him the appearance of solidity.

Deciding on the final shape of your robot's parts can involve a lot of redrawing, but going over your final lines in heavy pencil and erasing all the mistakes will make your final design much clearer.

Glossary

angular Having angles or sharp corners.

complementary Combining well with something else.

converge Join.

crevice A narrow crack or opening.

cumbersome Awkward.

dynamic Full of energy.

enhance Improve.

framework Basic structure.

geometric Conforming to the laws of geometry, the study of the properties and relationships of points, lines, angles, curves, surfaces and solids.

golden section The proportion of a straight line that occurs when you divide the line in two so that the ratio of the whole line to the larger part is equal to the ratio of the larger part to the smaller part.

harmonious Having a pleasing combination of parts or colours.

hexagon A two-dimensional shape with six sides.

highlight An area of very light tone in a painting that provides contrast or the appearance of illumination.

horizontal Parallel to the horizon.

humanoid A robot or alien with the basic shape of a human being.

joint Any of the parts of a body where bones are connected.

manga The literal translation of this word is "irresponsible pictures". Manga is a Japanese style of animation that has been popular since the 1960s.

mecha A Japanese shortening of the English word mechanical. Mecha refers to anything of a mechanical nature, including weapons, advanced body armour, vehicles and, of course, robots.

mutant A creature with an odd or deformed appearance.

parallel Lines or planes that are always the same distance apart and therefore never meet.

pastel A pale, soft colour.

perspective In drawing, changing the relative size and appearance of objects to allow for the effects of distance.

physique The shape and size of a body.

proportion The relationship between the parts of a whole figure.

recede Get further away from the observer.

segmented Divided into segments.

swatch Something used as a sample.

torso The upper part of the human body, not including the head and arms.

vertical Upright, or at a right angle to the horizon.

visor The hinged front part of a helmet, made of a transparent material and designed for the wearer to look through.

Further information

Books
The Art of Drawing Manga by Ben Krefta (Arcturus, 2003)

How to Draw Manga: A Step-by-Step Guide by Katy Coope
(Scholastic, 2002)

*Mecha Mania: How to Draw the Battling Robots, Cool Spaceships,
and Military Vehicles of Japanese Comics* by Christopher Hart
(Watson-Guptill Publications, 2002)

Step-by-Step Manga by Ben Krefta
(Scholastic, 2004)

Websites
http://www.polykarbon.com/
Click on "tutorials" for tips on all aspects of
drawing manga.

http://omu.kuiki.net/class.shtml
The Online Manga University.

http://members.tripod.com/~incomming/
Rocket's How to Draw Manga.

Note to parents and teachers:
Every effort has been made by the publishers to
ensure that these websites are suitable for
children and contain no inappropriate or offensive
material. However, because of the nature of the
Internet, it is impossible to guarantee that the
contents of these sites will not be altered. We
strongly advise that Internet access is supervised
by a responsible adult.

'Bye everyone! I hope you had fun learning how to draw manga.

Index